D1450705

ANSEL KRUT

ANSEL KRUT

With an essay by Nigel Cooke

Stuart Shave / Modern Art
in association with Koenig Books
2011

The Paintings of Ansel Krut

The colours in the painting may look cheerful at first, but they're ever so slightly polluted – pinks, turquoises and yellows are dirtied by a brown, or maybe black. And they're paling here and there, like a felt tip pen that's running out, or a child's toy left too long in the sun. The foody-looking gathering of bean/bratwurst forms in the middle of the painting is roughly symmetrical, so the mind finds a face – it's a perceptual default setting, like a child describing the front end of a car as happy, or sad, or cross. Ansel Krut knows this anthropomorphic programming is both a gift and a curse for painting – the spectator already knows what's there, but does this prehistoric knowledge close down the possibility of seeing the image in a new way? The organization of Krut's picture plays between the two, holding both possibilities side by side, at all times. It is the archetype of a face, at once crucial to the identity of the work and mysteriously beside the point, a subject – in both senses of the word – and an arrangement of oddly declassified objects. So from this paradoxical vantage point Krut's bean-formed face winks at us, letting us know we're on the right lines, and, equally importantly, on unstable ground.

A painting such as this – *Self Portrait with Bendy Balloons* (2007) – introduces us to the artist's world of skewed perceptions and perverse dualities. We are in the presence of a painting logic based on misrecognition and misinformation. The self-portrait here is, after all, the inverse of a face – less a collection of attributes inset or protruding from a solid head than a tower of rubbery shapes stacked in a void. In place of the unifying contour of a skull is recessional space, the frontier of which is perhaps a studio wall, hinting that at some point in the image's life there may have been an object in real space to refer to, a still-life setup of sorts. Onto this wall the facial features cast their bouncy shadows; in place of solidity this 'self' provides only platonic illusion, yet in doing so claims ownership of a personal imaginary lived exclusively through painting: I am *my* image.

Krut's personal imaginary, a vision inscribed in the handling of paint, has something resolutely ancestral about it, a hybrid historical feel at once prestigious and idiosyncratic. In many works, but most notably *Tulip & Lilly* (2009) and

Mountains With Eyes (2010), it keys the work into a high European modernism, perhaps specifically Parisian, in echoes of late Braque, Matisse and Picasso. The touch is spare, decisive and delicate, the character of line and mark informed by the primacy of drawing, as it was with Braque. Colour is set into these compositions with a clarity that works this drawing into a kind of question, as it did with Matisse, validating yet also challenging the growth of an image from a drawing into a painting, discussing what the difference might be and what the perceptual functions of each contribute to the expression of the image.

Yet to dwell too long on formal matters alone is to ignore what these paintings are providing us on another, altogether more affecting level. What Krut's works so skillfully and compellingly achieve is a dramatic break with the story of Euro-modern formal sophistication told through his painterly touch. In a kind of mutation of intent, Krut's ribald and oblique imagery wells up against the pedigree of a tried and tested pictorial modernity, which is in turn further subverted and 'remixed' by the artist's serious and hard-won empirical knowledge of paint and its application. Krut's duality comes down to this: the manual talent of the paintings' material technology is put to work in service of a perverse strain of irresponsibility, found in a lexicon of imagery that takes in booze, backsides and bananas, carrots, cocks, jackboots and jug-ears. Krut's layered maturity, as evidenced in the deft, sensitive and willfully economical handling of paint and line, apparently cries out for some sort of slapstick comeuppance in return; the worthy art history scholar is driven from the museum by the aggressive fun of the clown, all farts and flowers, pinwheels and screaming trumpets.

'What I dream of,' reflected Henri Matisse, in his now tired quote of 1908, 'is an art of balance, of purity and serenity, devoid of troubling or depressing subject matter … something like a good armchair that provides relaxation from fatigue.' Over the years, the image of this easy chair of painting has tranquilised discussions on Matisse, once the firebrand of the twentieth-century Parisian avant-garde, whose paintings were originally heralded as more dangerous than alcohol. Krut's *Armchair with Bottles* (2009) splices the two mythologies, combining inane homeliness and toxic excess. The chair here is not Matisse's fantasy: it's a figure who staggers forth unbalanced and impure, troubled and maybe even depressed, a *bad* armchair that offers no relaxation from fatigue … a big-eared, tanked-up

failure with a thumping pin-headache who swerved the promise of serenity, purity and balance and went on a bender instead. The lumpen status of this big, dumb chair mimics the shopworn feel of the Matisse quote, with its open invitation to art history to over-align his painting with the applied arts and, perhaps as a result, diminishing his ongoing relevance as a painter. The chair is therefore the perfect vehicle for Krut's perversity. The narrative and the drawn image pertaining to it create tension with the artist's painterly refinement – the thrilling palette of muted and high tones, subtly paced brushwork and complex shadow patterning – precisely because they are features that have evolved from the same thread of art history that gave us the armchair cliché.

Ansel Krut's sense of modernity, or at least its hold on his painterly touch, is in this sense deeply ambivalent. Being aware of the callow returns that visual references feed the artist, as well as the cheap shortcuts to meaning they provide the viewer, Krut's perversity involves spicing up the whole painting/image relationship with the mechanisms of the joke. The carrots that make up the facial structure in *Giants of Modernism 2 (Carrot Head)* (2009) may be derived from the geometry of intersecting lines that fix it into the composition, but it's hard to resist the sense that the carrots are a form of ridicule to the formal pleasantness of the pattern, too – they fight the pull of the 'good armchair', perhaps. Ambivalence generates both the pattern and the lurid male face that rears up out of it, all pince-nez, moustache and pretentious pointy beard. If this guy is a 'giant of modernism', then it's possible he represents part of the back-story of Krut's painting language in general. For this reason perhaps, the artist cannot let this prehistoric patriarch dominate proceedings – to the indignation of the man himself. With his exquisitely scrubbed carrot tops evoking both Picasso's re-workings of *Manet's Le Dejeuner sur l'Herbe* (1863), as well as jets of furious steam and smoke, he blows his top. This predecessor of European modernity – half Buckminster-Fuller, half Basil Fawlty – loses his authority as the carrots gain the ascendancy in the symbolic order of the image. This is the moment when Krut steers the identity of the image away from the painting's capacity to unify, to build rational sense. And the unique point is that this happens not through a predictable destruction of the image, but in its very completion.

This process or movement of attitudes is not only a function of the artist's

relationship to history; it takes us to the heart of Krut's conception of painting itself. Ambivalence, with its natural articulation in paradox, is the heartbeat of his painting process. The irreverence towards finesse witnessed in the slapstick trouncing of painterly verve is, for Krut, the core reality of what it means to make paintings. The ridicule the image visits upon the stylishness of the handling is not an opposition facing it from a defensive or privileged position, but an implicit feature of what a painting is to the artist in its very nature. What excites about these paintings is not the sense that a dash of delinquency has been tactically imported into the picture to snatch it from the jaws of decoration, but that in terms of Krut's conception of the painting process the two are innately and irreversibly the same thing.

In this regard the privacy of the studio – where doubts and troubles about painting run the show – binds the various strains of Krut's duality and ambivalence together. Ambivalence is the mindset of work in progress, the state that holds together multiple possibilities within the intimate trance of time spent in the studio. This is an experience that necessarily cuts out the world at large, and projects in its place a fictional viewer somewhere in the room as the antithesis of the artist's moves and decisions, a voice of dissent and antagonism. The circuit of ambivalence is thus made complete. The rigour of his negotiations with this 'viewer' become the painting/image negotiations that we see in a finished work – perhaps providing the feel of honesty and courage that the works put across. The artist's ambivalence during studio work is then the root of the negotiations we see taking place at the level of the painted image; it's the original force that strips the potentially crazy images of any triviality, gives them depth, and transmits the feeling of eavesdropping on someone's thoughts.

Ears (2010) perhaps most conspicuously reads as the product of this chain of negotiations. Like much of Krut's work, it is a composition organised around a centre, the fluid forms fanning outwards, filling the space with loose, organic shapes. At the centre these cluster together as a stack of ears that resemble a face, the whorls of the ear structure becoming googly eyes: a hearing instrument with vision. There is a strange synaesthesia – the transferring of one sense modality onto another – to these 'seeing ears' – a scrambling of senses that feels like the unpredicted outcome of (and a symbol for?) the tensions and contradictions

inherent in the painting process. On either side of the ear-face, showbiz jazz hands open out, at once bold and beseeching, confrontational yet craving acceptance. The impression is of an anthropomorphized abstraction, the painting 'journey' coming to life right at the end like a monstrous offspring, urging the maker to accept it, live with it, as a product of himself.

Other humanoid characters carry the same sense of irreversible consequences, of the power of the image to unsettle and surprise perhaps even the painter who made them. The figure in *Citizen Bottle* (2009), for example, similarly embodies the unnerving outcomes of the privacy and intensity of painting. In the centre of the Bacon-esque flesh-form 'head' on top of the bottle, an anus takes the place of all other facial features, skipping the syntax of the polite still-life the head has morphed from. Amongst the quiet care of the composition, it scans like a profanity shouted in the street. It feels as momentary as that – an impulse, a sudden change of heart, and yet the life of the image is given a new twist, from here licensing a splendid double moustache and a magically levitating hat. We feel a change in pace in the studio, the coming together of a sequence of intellectual cause and effect, leaving the artist to take responsibility for the outcome, come what may. Again, the changing currents of the studio experience come to the surface, and we are provided with a compelling sense of rightness in the wrongness, a brand of almost heroic inevitability. Therefore imagery, conventionally the site of reconciliation between language and materiality, is in the paintings of Ansel Krut not only the nexus of open and profound ambivalence, but also the pure and heartfelt articulation of its attendant doubts. What finally reaches out to us from these strange yet unforgettable images is an array of opposing values that remain in permanent dialogue with one another, backing up pictures possessed of luminous beauty and a cracked, anarchic laughter.

Nigel Cooke

TABLE OF REPRODUCTIONS

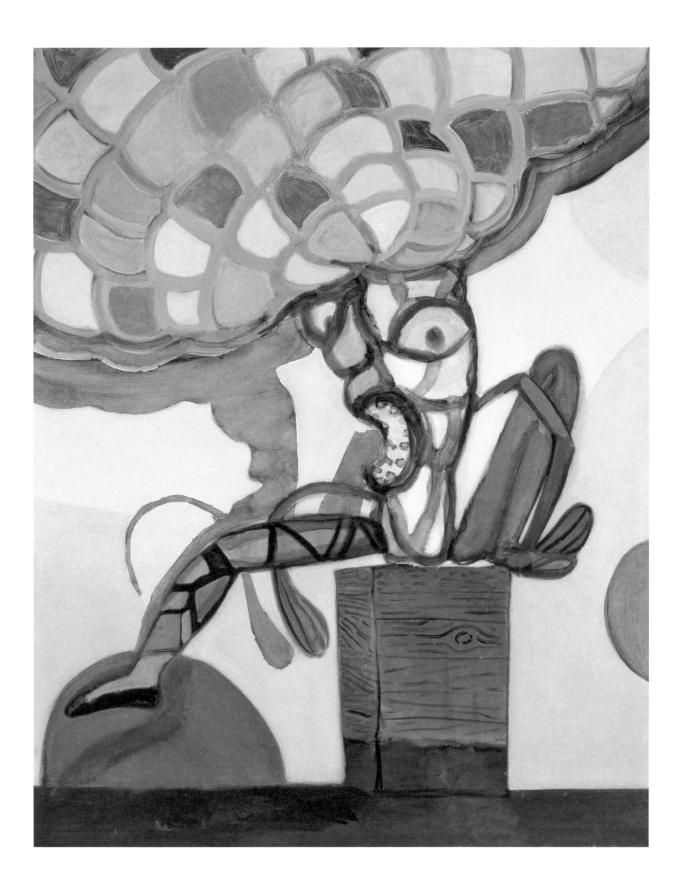

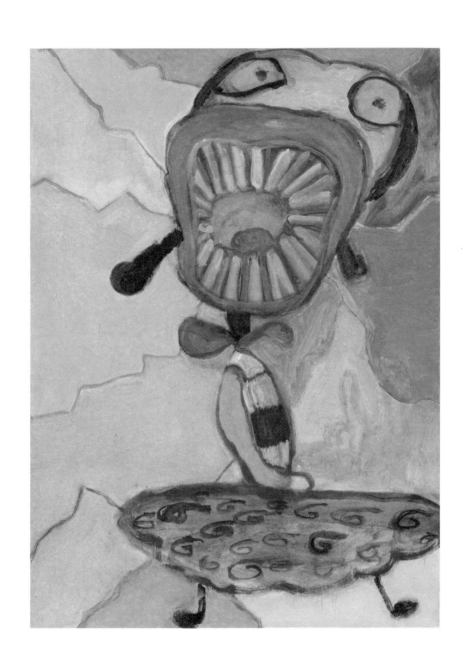

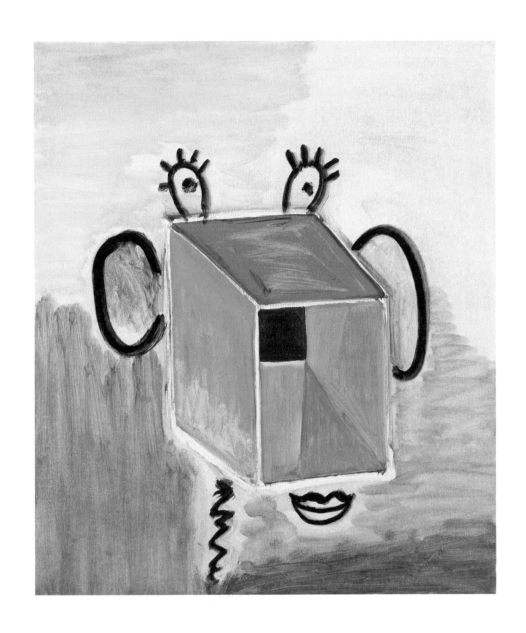

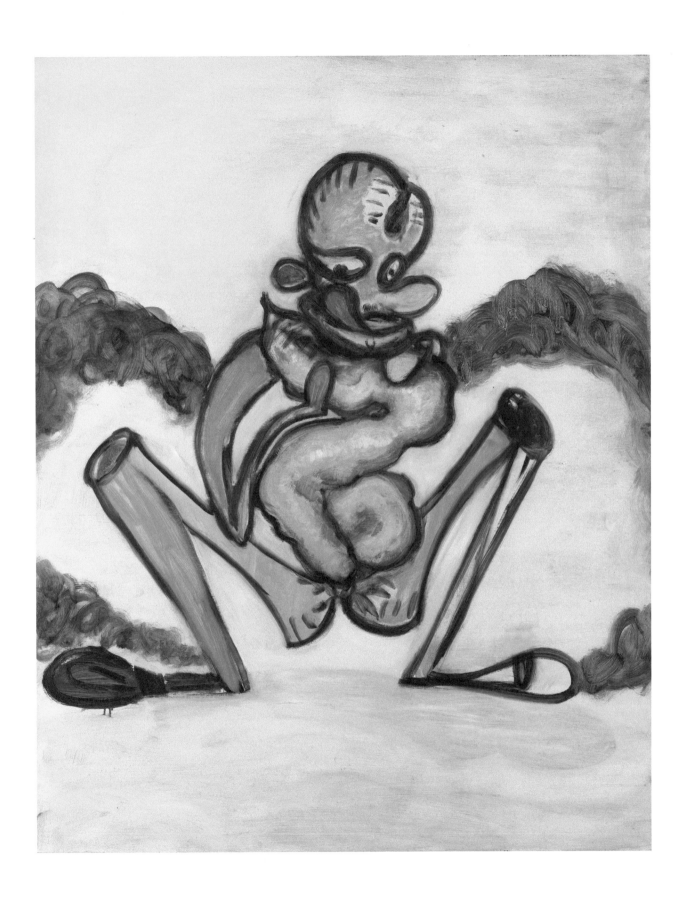

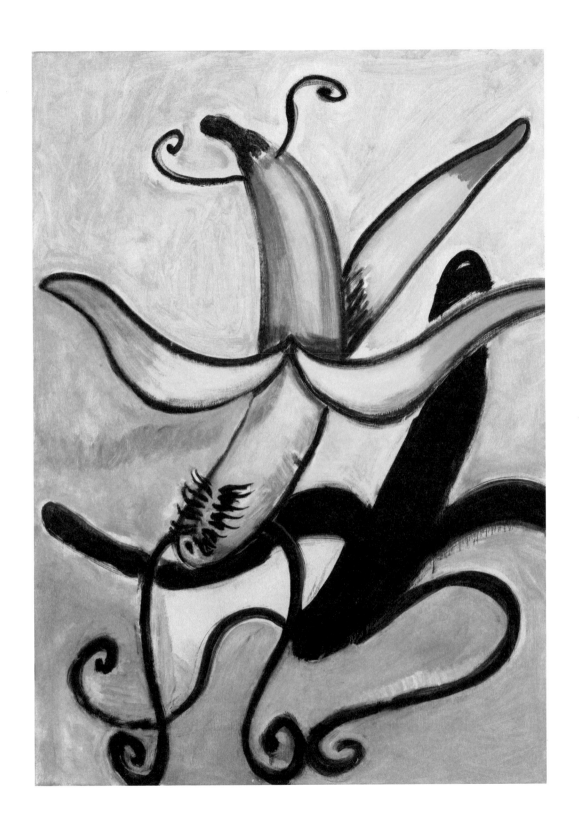

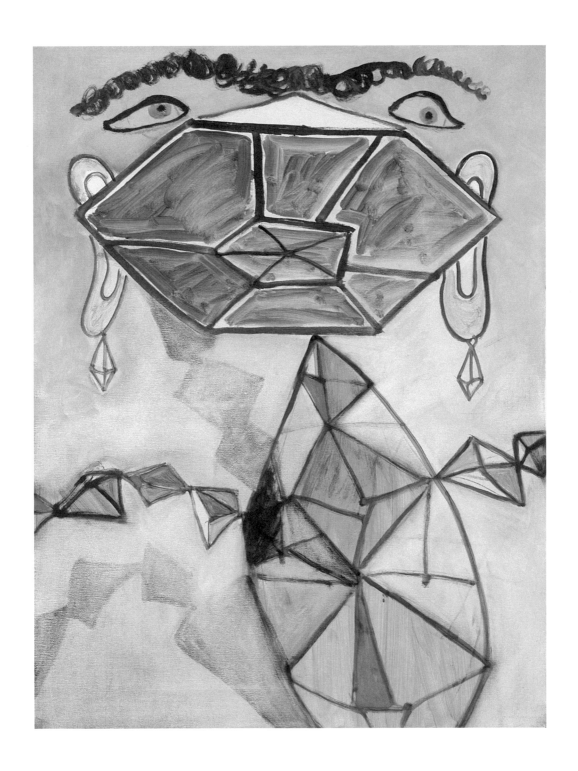

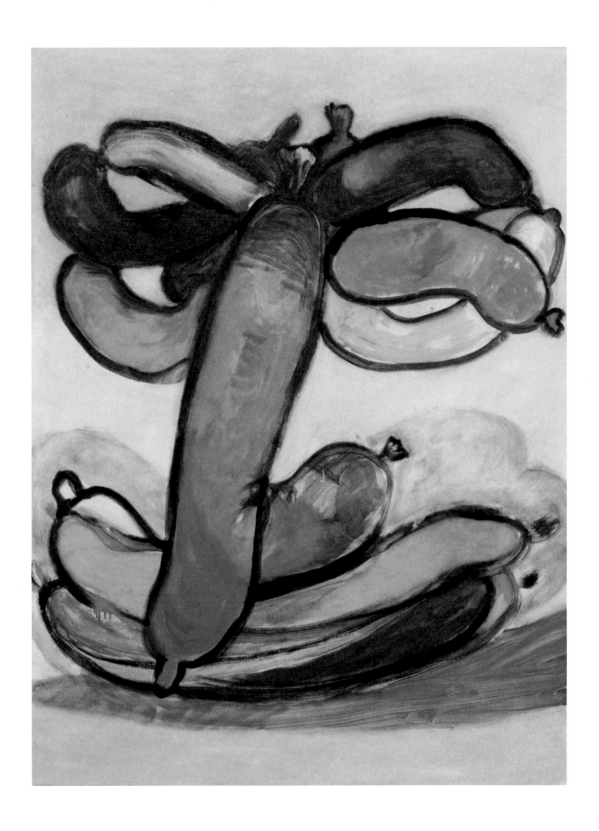

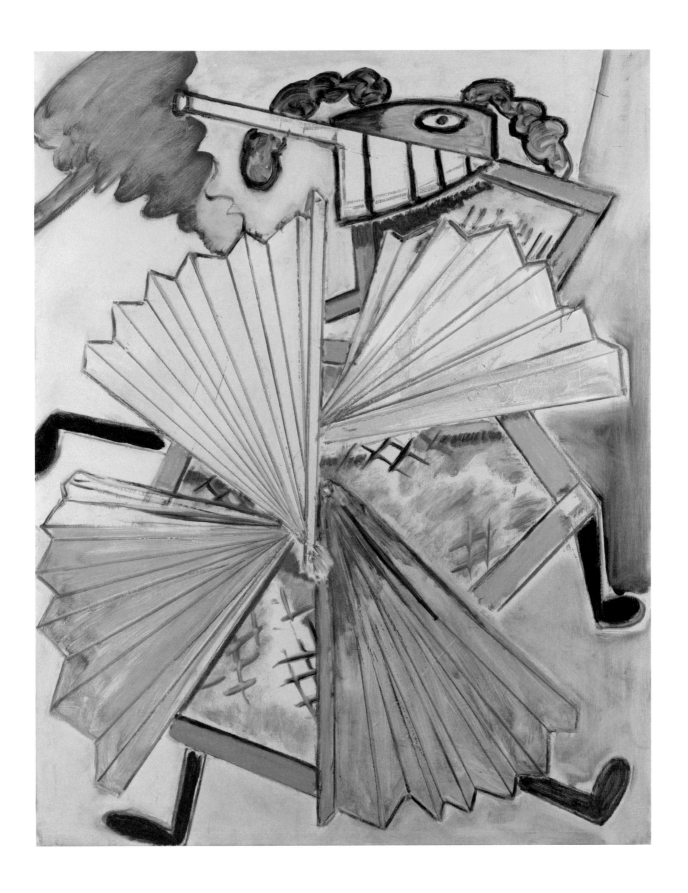

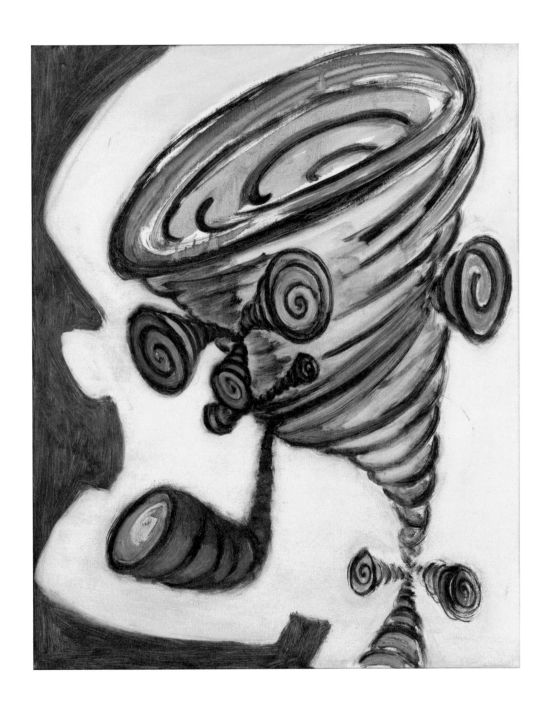

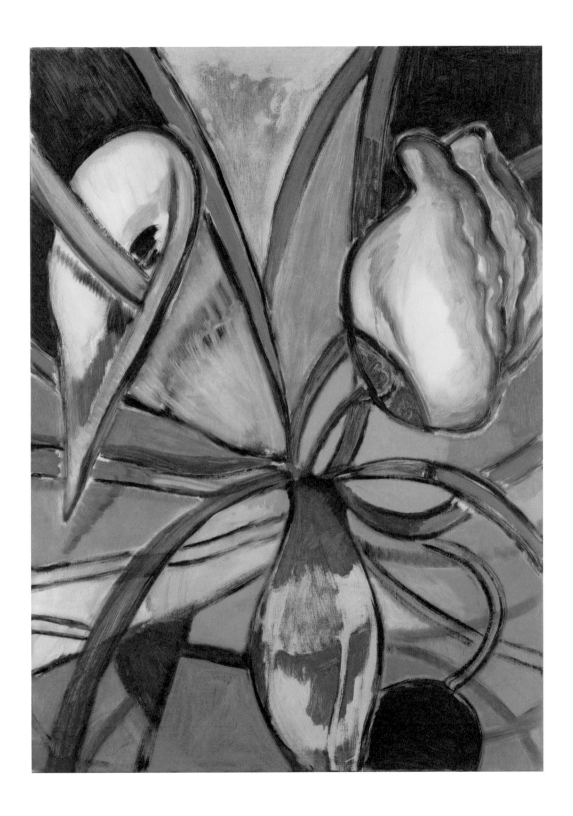

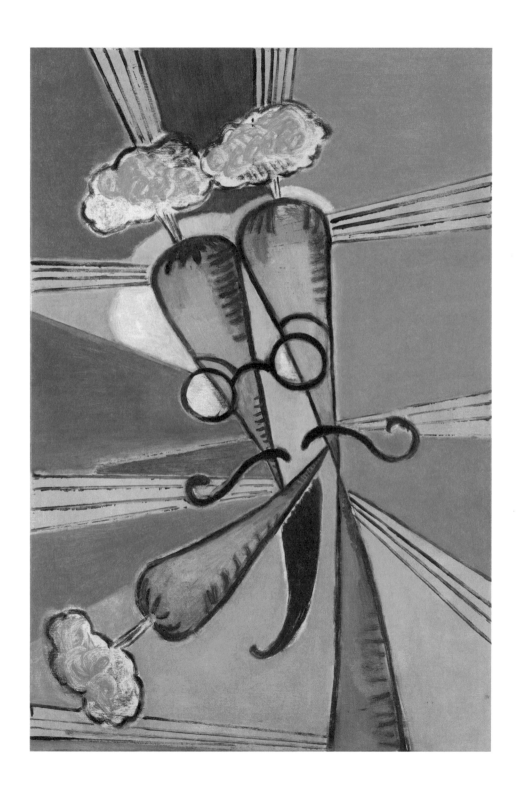

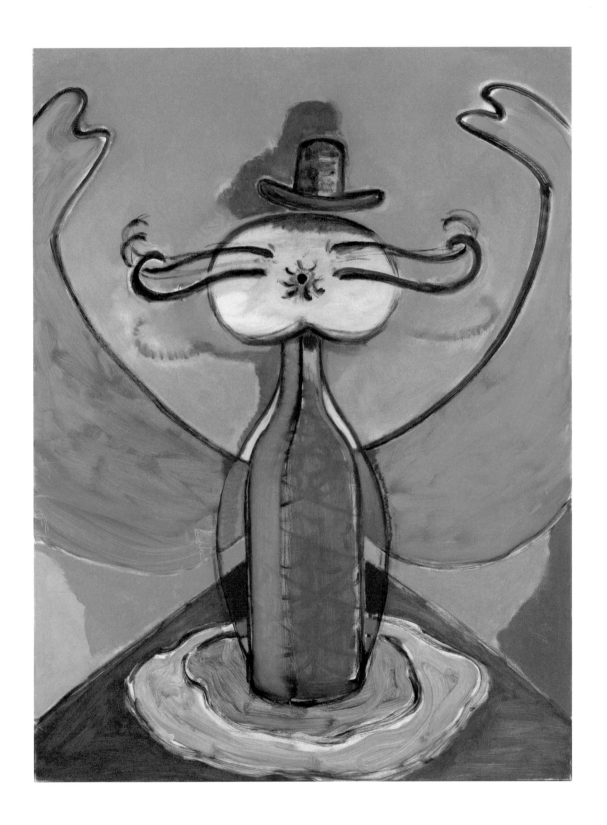

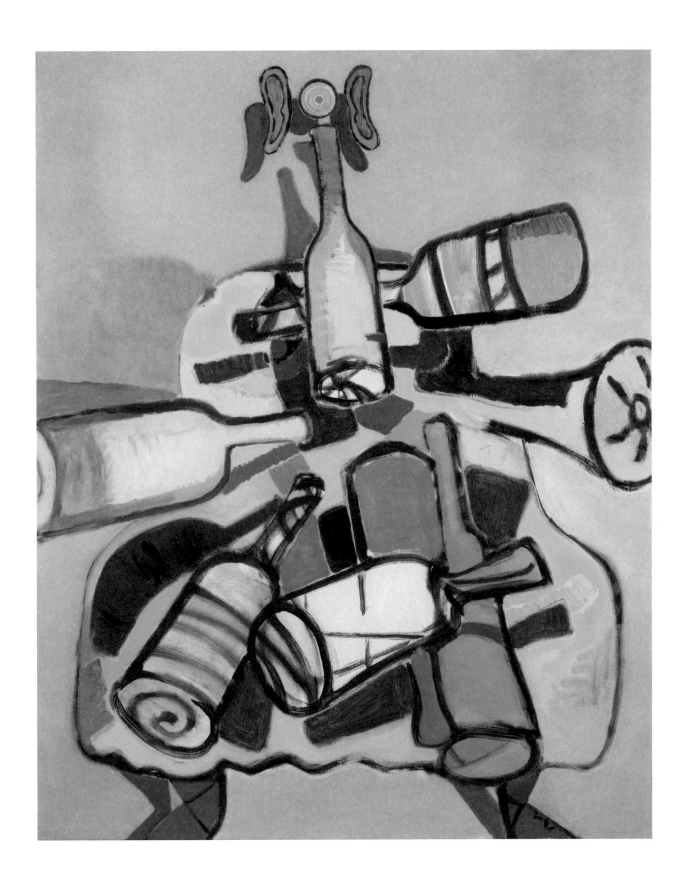

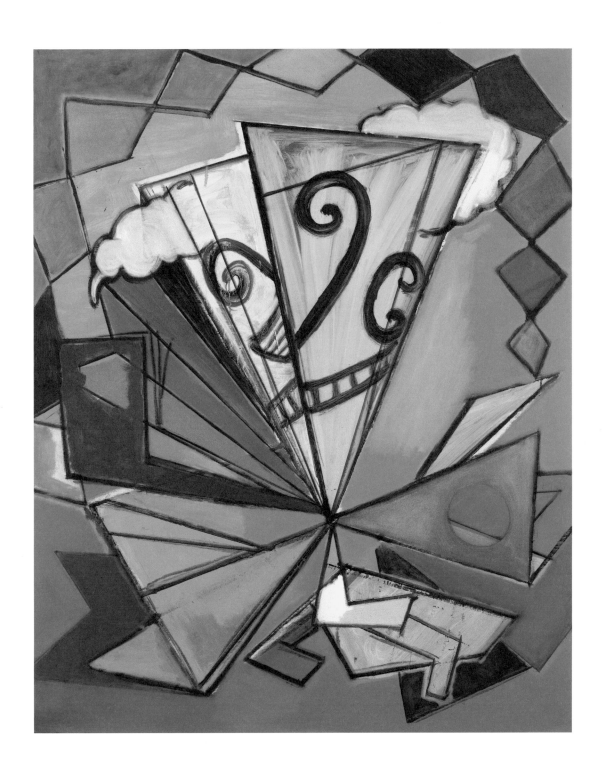

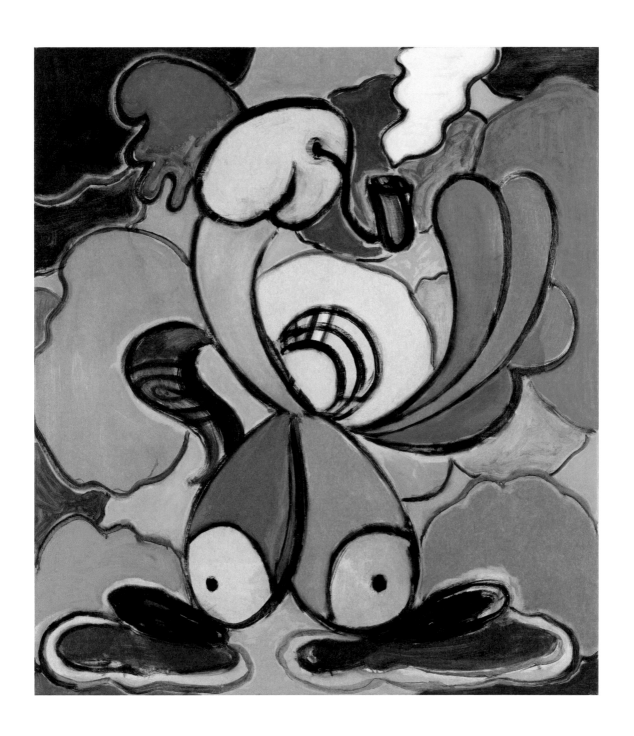

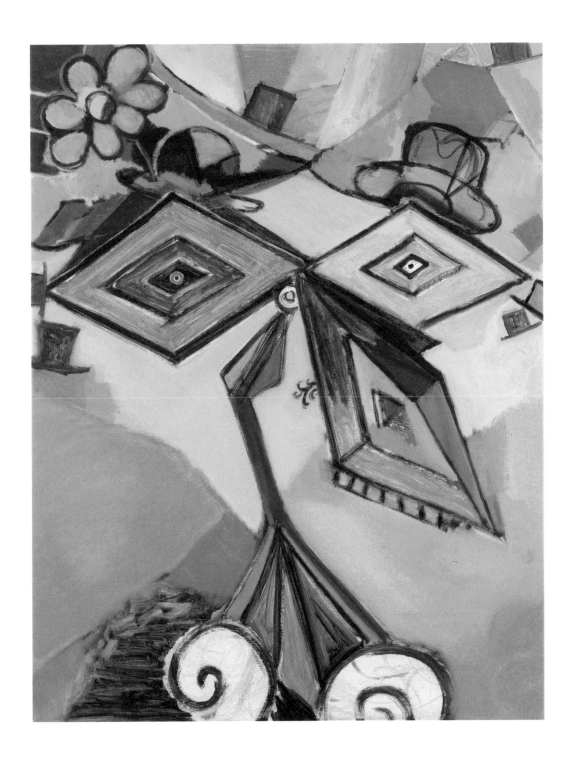

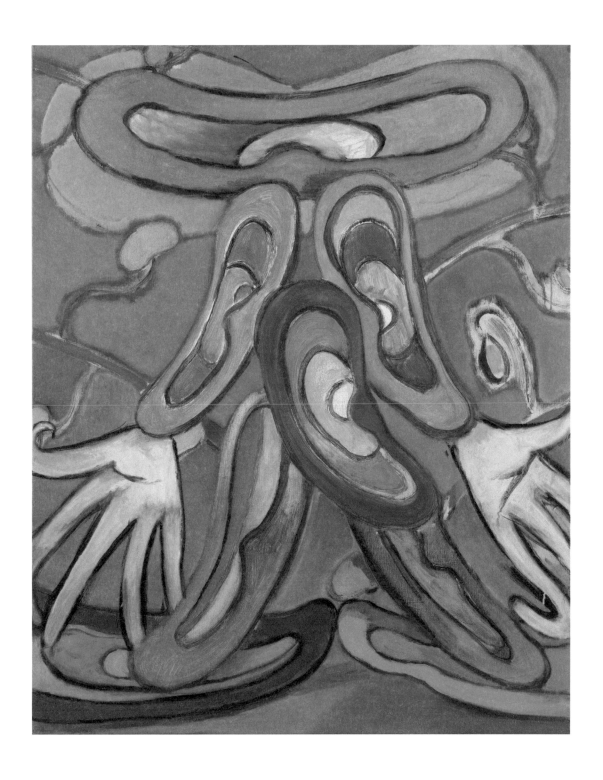

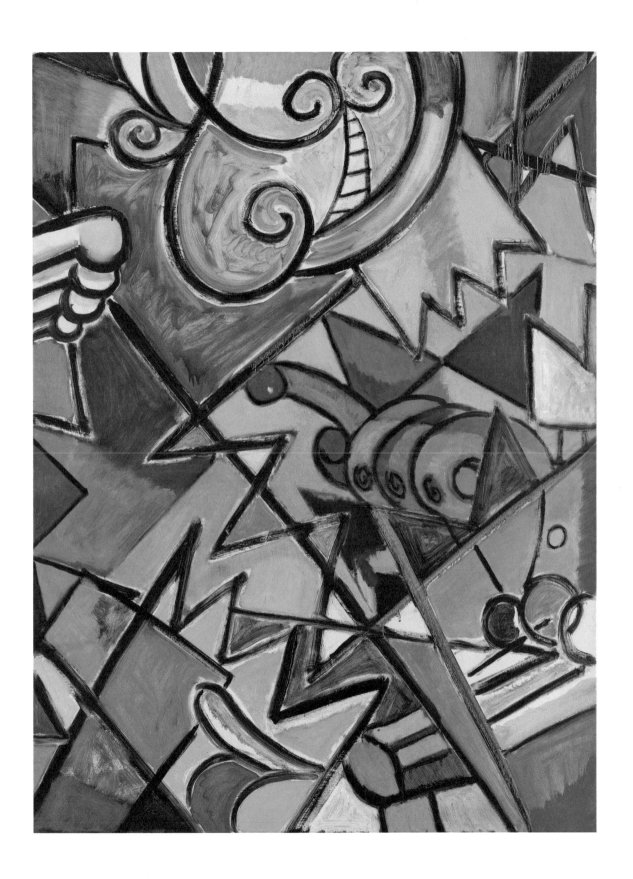

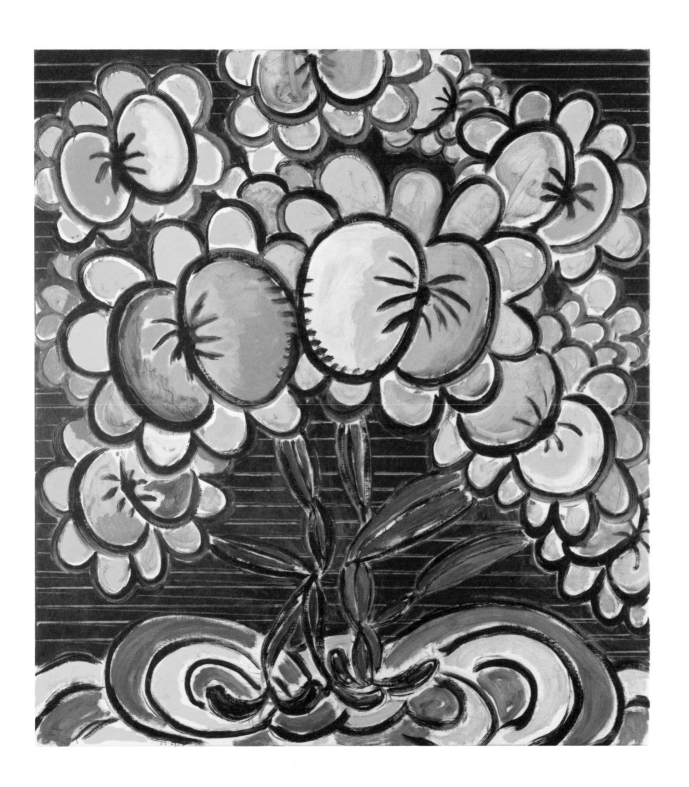

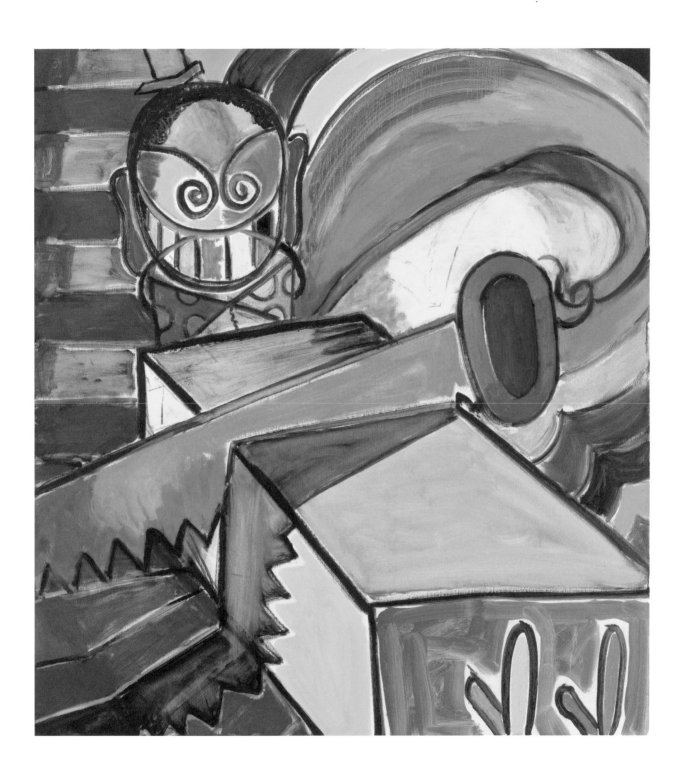

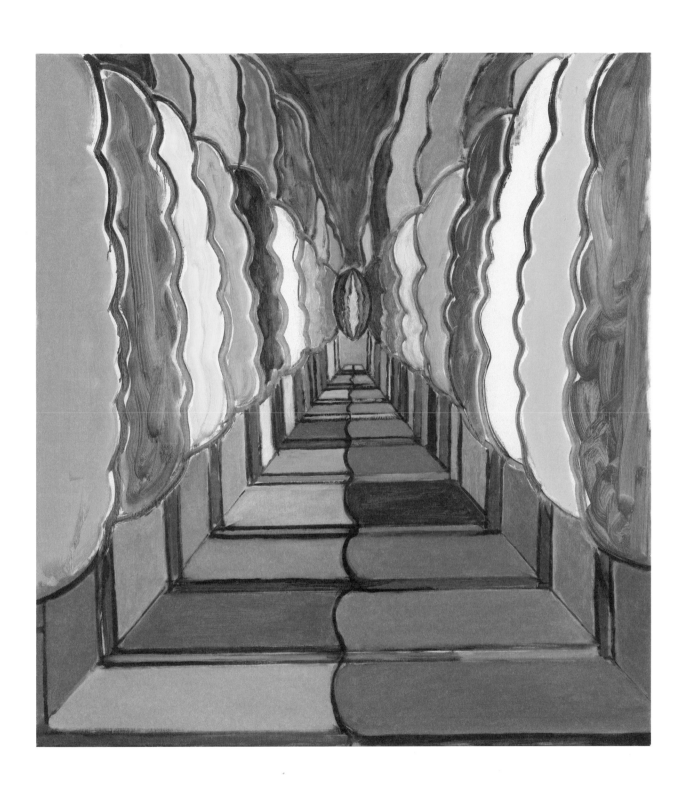

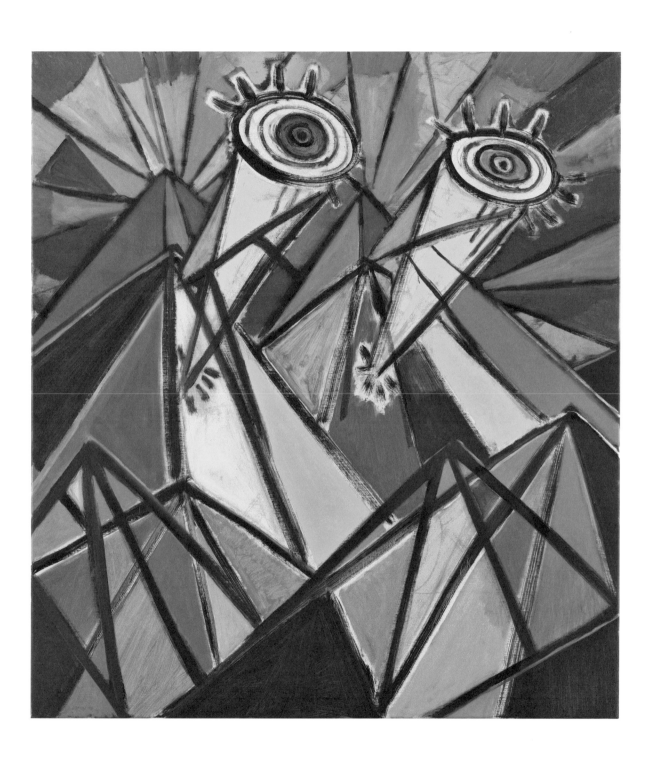

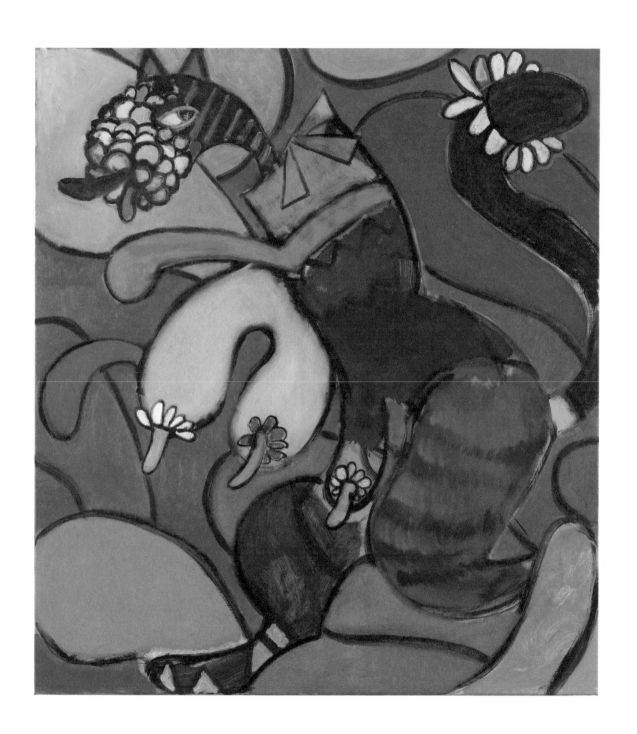

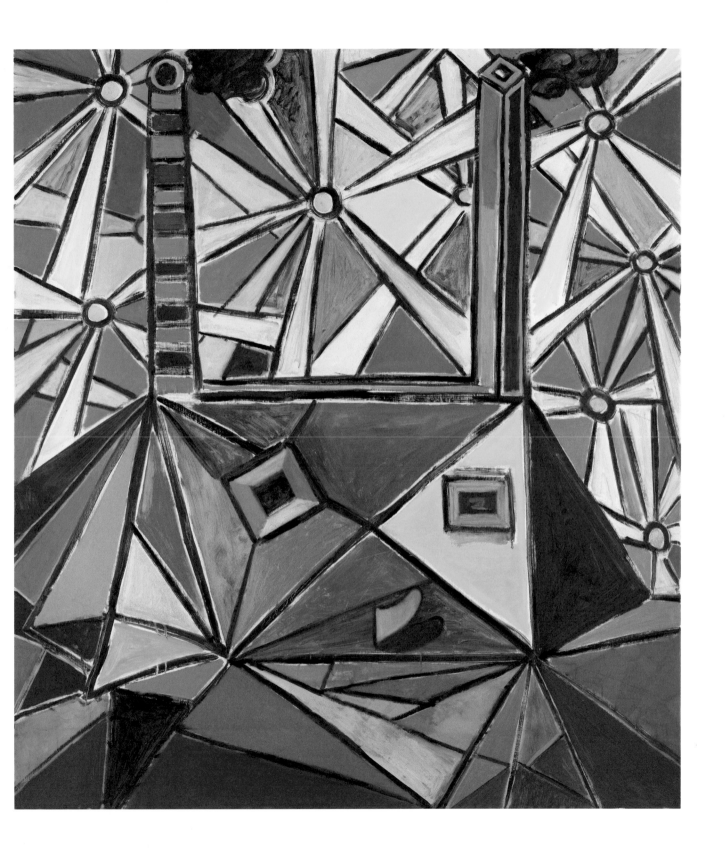

CATALOGUE LIST

All works oil on canvas

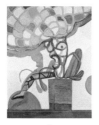

1
Peanut with Bulging Head, 2004
155.5 × 122 cm / 61¼ × 48 ins

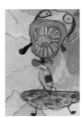

2
Sonic Boom 2004
56 × 41 cm / 22 × 16¼ ins

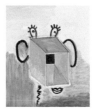

3
Box Head 2006
70 × 60 cm / 27½ × 23⅔ ins

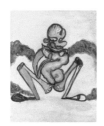

4
Man Eating His Intestines 2006
152 × 122 cm / 59⅞ × 48 ins

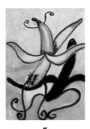

5
Rah-Rah-Banana 2007
110 × 80 cm / 43¼ × 31½ ins

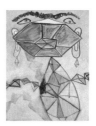

6
Bling 2007
93 × 72 cm / 36⅔ × 28⅓ ins

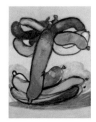

7
Self Portrait with
Bendy Balloons 2007
120 × 90 cm / 47¼ × 35½ ins

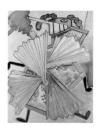

8
Exotic Dancer 2009
150 × 120 cm / 59¼ × 47¼ ins

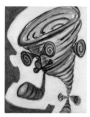

9
Giants of Modernism 1
(Vortex Head with Pipe) 2009
76.2 × 61.2 cm / 30 × 24⅛ ins

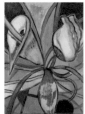

10
Tulip & Lily 2009
110 × 80 cm / 43¼ × 31½ ins

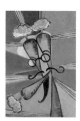

11
Giants of Modernism 2
(Carrot Head) 2009
90 × 60 cm / 35½ × 23⅔ ins

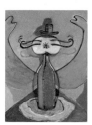

12
Citizen Bottle 2009
120 × 90 cm / 47¼ × 35½ ins

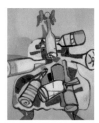

13
Armchair and Bottles 2009
150 × 120 cm / 59 × 47¼ ins

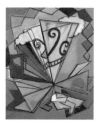

14
Origami Aviator 2009
110 × 90 cm / 43¼ × 35½ ins

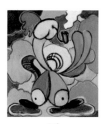

15
Rooster in the Clouds 2009
100 × 90 cm / 39⅓ × 35½ ins

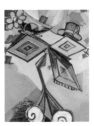

16
Portrait with many Hats 2010
90 × 70 cm / 35½ × 27½ ins

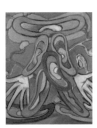

17
Ears 2010
100 × 80 cm / 39.4 × 31½ ins

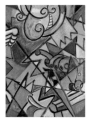

18
Shattered Man 2010
120 × 90 cm / 47¼ × 35½ ins

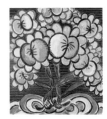

19
Arse Flowers in Bloom 2010
120 × 110 cm / 47¼ × 43¼ ins

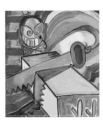

20
Man sawing himself in two 2010
120 × 110 cm / 43¼ × 47¼ ins

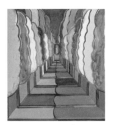

21
Avenue of the Flowers 2010
120 × 110 cm / 47¼ × 43¼ ins

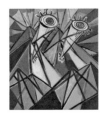

22
Mountains with Eyes 2010
110 × 100 cm / 43¼ × 39⅓ ins

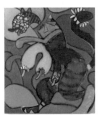

23
Cat in Moonlight 2010
100 × 90 cm / 39⅓ × 35½ ins

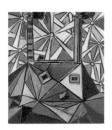

24
A Factory working through
the Night 2011
157 × 142 cm / 61¾ × 55⅞ ins

First published by Stuart Shave/Modern Art
in association with Koenig Books, 2011

Stuart Shave/Modern Art
23/25 Eastcastle Street
London
W1W 8DF
Tel. +44 (0) 207 2799 7950
www.modernart.net

Koenig Books Ltd
At the Serpentine Gallery
Kensington Gardens
London W2 3XA
www.koenigbooks.co.uk

All works © 2011 Ansel Krut
Text © 2011 Nigel Cooke
Publication © 2011 Stuart Shave/Modern Art
and Koenig Books, London

Designed and produced by Peter Willberg

ISBN 978-3-86560-984-7

Printed in Belgium

Distribution:

Buchhandlung Walther König, Köln
Ehrenstraße 4, 50672 Köln, Germany
Tel. +49 (0) 221 / 20 59 6 53
Fax +49 (0) 221 / 20 59 6 60
verlag buchhandlung-walther-koenig.de

Switzerland
Buch 2000
c/o AVA Verlagsauslieferungen AG
Centralweg 16
CH-8910 Affoltern a.A.
Tel. +41 (44) 762 42 00
Fax +41 (44) 762 42 10
buch2000 ava.ch

UK & Eire
Cornerhouse Publications
70 Oxford Street
GB-Manchester M1 5NH
Tel. +44 (0) 161 200 15 03
Fax +44 (0) 161 200 15 04
publications cornerhouse.org

Outside Europe
D.A.P. / Distributed Art Publishers, Inc.
155 6th Avenue, 2nd Floor
USA-New York, NY 10013
Tel. +1 (0) 212 627 1999
Fax +1 (0) 212 627 9484
eleshowitz dapinc.com